QUOTATION BOOK

Our National Parks

Applewood Books
Carlisle, Massachusetts

978-1-4290-9410-8

Published in cooperation with the National Park Foundation

To inquire about this edition
or to request a free copy
of our current catalog
featuring our best-selling books, write to:
Applewood Books
P.O. Box 27
Carlisle, MA 01741
For more complete listings,
visit us on the web at:
www.awb.com

10 9 8 7 6 5 4 3 2
MANUFACTURED IN THE UNITED STATES OF AMERICA

In 1872 the United States established Yellowstone as its first national park. But the American impulse to preserve magnificent landscapes and memorialize history, people, and places reaches back to our roots. The thoughts of poets, politicians, scientists, religious leaders, conservationists, naturalists, and philosophers are represented chronologically here. The words of some of these thinkers are inspirational—they convey awe and wonder and their authors serve as witnesses to the beauty and importance of our national parks. Some quotations are testimony to the farsightedness of the conservation and preservation movements in America. And many of the quotes show the extraordinary vision and passion from leaders within the National Park Service, Department of the Interior, the U.S. Congress, and the Office of the President. When read together, these quota-

tions show how places and national character—
the land, our past, and our identity—have driven
thinkers for centuries.

It is extraordinary that every American is part-
owner of some of the most beautiful, historically
important, and culturally potent spaces in the na-
tion. The words quoted herein make it abundantly
clear that the National Park System has long been
understood as a meaningful example of Ameri-
can democracy at work. And as we celebrate the
start of the second century of our national parks,
we look to the next generation to articulate with
practicality, passion, and poetry the importance
of giving to their children our "greatest gift."

—Applewood Books

"Study the past if you would define the future."

—Confucius
Chinese philosopher of the Spring and Autumn period of
Chinese history

"Listen to nature's voice—it contains treasures
for you."

—Huron Tribe proverb

"The forest rewards those who walk through it."

—Bemba proverb
Zambia, Africa

"He plants trees to benefit another generation."

**—Cicero, *Three Books of Offices; or, Moral Duties*,
44 BC**
Roman philosopher, orator, and politician

"We do not inherit the earth from our ancestors; we borrow it from our children."
 —**Navajo Tribe proverb**

"When a man moves away from nature his heart becomes hard."
 —**Lakota Tribe proverb**

 "How is the spirit of a free people to be formed and animated and cheered, but out of the storehouse of its historical recollections?"
 —**Edward Everett,** *The Christian Messenger,* **1832**
 Massachusetts pastor, politician, and educator

"The interminable forests should become graceful parks, for use and delight."
 —**Ralph Waldo Emerson, 1844 speech**
 American poet and author

"In Wildness is the preservation of the world."

 —Henry David Thoreau, "Walking," 1862
 American author, poet, philosopher, and naturalist

"Why should not we…have our national preserves…in which the bear and panther, and some even of the hunter race, may still exist, and not be 'civilized off the face of the earth'…for inspiration and our true re-creation? Or should we, like villains, grub them all up for poaching on our own national domains?"

 —Henry David Thoreau, *Atlantic Monthly,* 1858
 American author, poet, philosopher, and naturalist

"We pass with rapid transition from one remarkable vision to another, each unique of its kind and surpassing all others in the known world. The intelligent American will one day point on the map to this remarkable district with the conscious pride that it has not its parallel on the face of the globe."

 —Ferdinand Hayden, *Scribner's Monthly,* vol. 3, 1872
 Geologist and government-sponsored explorer, writing
 about the Grand Canyon

"It is desirable that some large and easily accessible region of American soil should remain as far as possible in its primitive condition, at once a museum for the instruction of the students, a garden for the recreation of the lovers of nature, and an asylum where indigenous tree[s]...plant[s]...beast[s] may dwell and perpetuate their kind."

—**George Perkins Marsh,** *The Earth as Modified by Human Action,* **1874**
American diplomat and one of America's first conservationists

"The clearest way into the Universe is through a forest wilderness."

—**John Muir,** *John of the Mountains: The Unpublished Journals of John Muir,* **1890**
Founder of the Sierra Club

"There are few sensations I prefer to that of galloping over these rolling limitless prairies, with rifle in hand, or winding my way among the barren, fantastic and firmly picturesque deserts of the so-called Bad Lands."

—**Theodore Roosevelt,** *Hunting Trips of a Ranchman,* **1891**
President of the United States

"The glories and beauties of form, color, and sound unite in the Grand Canyon—forms unrivaled even by the mountains, colors that vie with sunsets, and sounds that span the diapason from tempest to tinkling raindrop, from cataract to bubbling fountain."

> —John Wesley Powell, *The Exploration of the Colorado River and Its Canyons,* 1895
> American geologist and explorer, director of the U.S. Geological Survey and the Smithsonian's Bureau of Ethnology

"Nowhere will you see the majestic operations of nature more clearly revealed beside the frailest, most gentle and peaceful things. Nearly all the park is a profound solitude. Yet it is full of charming company, full of God's thoughts, a place of peace and safety amid the most exalted grandeur and eager enthusiastic action, a new song, a place of beginnings abounding in first lessons on life, mountain-building, eternal, invincible, unbreakable order; with sermons in stones, storms, trees, flowers, and animals brimful of humanity."

> —John Muir, "The Yosemite National Park," *Atlantic Monthly,* August 1899
> Founder of the Sierra Club

"Thousands of tired, nerve-shaken, over-civilized people are beginning to find out that going to the mountain is going home; that wildness is necessity; that mountain parks and reservations are useful not only as fountains of timber and irrigating rivers, but as fountains of life."

—**John Muir, *Our National Parks*, 1901**
Founder of the Sierra Club

"National Parks are the best idea America ever had."

—**Lord James Bryce, early twentieth century, exact date unknown**
British ambassador to the U.S., politician, and scholar

"But look again! Those terrifying, frowning walls are moving, are changing! A new light is not only creeping over them, but is coming out from their very shadows. See those flattened slopes above the dark sandstone on top of the granite; even at this very moment they are being colored in gorgeous stripes of horizontal layers of yellow, brown, white, green, purple. What means this wondrous change? Wherein lies this secret of the great canyon?"

—**Robert B. Stanton, *The Grand Canyon of Arizona*, 1902**
American author

"I earnestly recommend the establishment of
a Bureau of National Parks. Such legislation is
essential to the proper management of those
wondrous manifestations of Nature, so startling
and so beautiful that everyone recognizes the
obligations of the Government to preserve
them for the edification and recreation of the
people.... Every consideration of patriotism and
love of Nature and of beauty and of art requires
us to expend money enough to bring all of
these natural wonders within easy reach of our
people."

 —**William H. Taft, special message to Congress, 1911**
 President of the United States

"Everybody needs beauty as well as bread, places
to play in and pray in, where nature may heal
and give strength to body and soul."

 —**John Muir, *The Yosemite*, 1912**
 Founder of the Sierra Club

"America's national parks will ultimately contribute more to the moral strength of the nation than all the law libraries in the land."

—Lord James Bryce, in a letter to John Muir, date unknown
British ambassador to the U.S., politician, and scholar

"We come and go, but the land is always here. And the people who love it and understand it are the people who own it—for a little while."

—Willa Cather, *O Pioneers!*, part V, chapter 3, 1913
American author

"Within National Parks is room—glorious room—room in which to find ourselves, in which to think and hope, to dream and plan, to rest and resolve."

—Enos Mills, *Your National Parks*, 1917
American naturalist and homesteader; played a key role creating Rocky Mountain National Park

"The parks do not belong to one state or to one section....The Yosemite, the Yellowstone, the Grand Canyon are national properties in which every citizen has a vested interest."

—**Stephen T. Mather, 1920 Report of the Department of the Interior**
National Park Service Director 1917–1929

"What a joy it is to feel the soft, springy earth under my feet once more, to follow grassy roads that lead to ferny brooks where I can bathe my fingers in a cataract of rippling notes, or to clamber over a stone wall into green fields that tumble and roll and climb in riotous gladness!"

—**Helen Keller, *The Story of My Life*, 1921**
Author and activist

"The more civilized man becomes, the more he needs and craves a great background of forest wildness, to which he may return like a contrite prodigal from the husks of an artificial life."

—**Ellen Burns Sherman, *On the Manuscripts of God*, 1918**
American author

"A national park should be as sacred as a temple."

 —**Henry van Dyke, 1926**
 Poet and author

"The National Parks are more than the storehouses of Nature's rarest treasures. They are the playlands of the people, wonderlands easily accessible to the rich and the humble alike."

 —**Horace M. Albright, *"Oh, Ranger!": A Book about the National Parks*, 1928**
 National Park Service Director, 1929–1933

"It is now recognized that [National] Parks contain more than scenery."

 —**Harold C. Bryant, 1929**
 Cofounder, Yosemite Free Nature Guide Service

"In the United States the best of our natural scenery and our most interesting scientific and historic places are retained in public ownership, for the benefit and use of all people."

 —**Isabelle F. Story, *Pamphlets on Forest Recreation*, vol. 4, 1939**
 Editor and first National Park Service Information Officer, 1916–1954

"A river is a treasure."

—Oliver Wendell Holmes, 1931 speech
Associate Justice of the U.S. Supreme Court, 1902–1932

"In no other way is the upward trend of our modern civilization so well exemplified as in the establishment, development, and increasing use of our National Park and Monument System.... Where once the best in scenery, as well as in everything else, was reserved for the use of those most favored, and for the pleasure of kings and princes, today every American citizen or visitor to our shores may enjoy the most priceless offerings of nature. Democracy is believed to be still in the experimental stage, but surely any system that institutes and makes successful such a magnificent experiment cannot fail of its ultimate purpose."

—Ray Lyman Wilbur, *American Civic Annual,* **vol. 3, 1931**
U.S. Secretary of the Interior, 1929–1933

"If I had my way about national parks, I would create one without a road in it. I would have it impenetrable forever to automobiles, a place where man would not try to improve upon God."

—**Harold L. Ickes, May 1933 speech**
U.S. Secretary of the Interior, 1933–1946

"Parks are the dietetics of the soul—a refuge, a place to regain spiritual balance and find strength and, if needed, a place of resignation from the turbulent world without."

—**Richard Lieber, 1935 speech**
American conservationist

"There is nothing so American as our national parks.... The fundamental idea behind the parks...is that the country belongs to the people, that it is in process of making for the enrichment of the lives of all of us."

—**Franklin D. Roosevelt, 1936 speech**
President of the United States

"Trees give peace to the souls of men."

—**Nora Waln, *Reaching for the Stars*, 1939**
American writer and journalist

"The American way of life consists of something that goes greatly beyond the mere obtaining of the necessities of existence. If it means anything, it means that America presents to its citizens an opportunity to grow mentally and spiritually, as well as physically. The National Park System and the work of the National Park Service constitute one of the Federal Government's important contributions to that opportunity. Together they make it possible for all Americans—millions of them at first-hand—to enjoy unspoiled the great scenic places of the Nation.... The National Park System also provides, through areas that are significant in history and prehistory, a physical as well as spiritual linking of present-day Americans with the past of their country."

—**Newton B. Drury, *Forestry Pamphlet: Conservation,* vol. 25**
National Park Service Director, 1940–1951

"There are certain values in our landscape
that ought to be sustained against destruction
or impairment, though their worth cannot be
expressed in money terms. They are essential to
our 'life, liberty, and pursuit of happiness;' this
Nation of ours is not so rich it can afford to lose
them; it is still rich enough to afford to preserve
them."

 —Newton B. Drury, date unknown
 National Park Service Director 1940–1951

"When you take a flower in your hand and really
look at it, it's your world for the moment. I want
to give that world to someone else. Most people
in the city rush around so, they have no time to
look at a flower. I want them to see it whether
they want to or not."

 —Georgia O'Keeffe, *New York Post*,
 May 16, 1946
 American painter

"When a society or a civilization perishes, one condition may always be found. They forgot where they came from. They lost sight of what brought them along. The hard beginnings were forgotten and the struggles farther along. They became satisfied with themselves. Unity and common understanding there had been, enough to overcome rot and dissolution, enough to break through their obstacles. But the mockers came. And the deniers were heard. And vision and hope faded. And the custom of greeting became 'What's the use?' And men whose forefathers would go anywhere, holding nothing impossible in the genius of man, joined the mockers and deniers. They forgot where they came from. They lost sight of what brought them along."

—Carl Sandburg, *Remembrance Rock,* **1948**
American poet and writer; Pulitzer Prize winner

"Something will have gone out of us as a people
if we ever let the remaining wilderness be
destroyed; if we permit the last virgin forests to
be turned into comic books and plastic cigarette
cases; if we drive the few remaining members
of the wild species into zoos or to extinction;
if we pollute the last clear air and dirty the last
clean streams and push our paved roads through
the last of the silence, so that never again will
Americans be free in their own country from
the noise, the exhausts, the stinks of human
and automotive waste. And so that never again
can we have the chance to see ourselves single,
separate, vertical and individual in the world,
part of the environment of trees and rocks and
soil, brother to the other animals, part of the
natural world and competent to belong in it....
We need wilderness preserved—as much of it as
is still left, and as many kinds—because it was the
challenge against which our character as a people
was formed. The reminder and the reassurance
that it is still there is good for our spiritual health
even if we never once in ten years set foot in it."

—Wallace Stegner, *Marking the Sparrow's Fall:
The Making of the American West,* 1948
American novelist and historian

"We abuse land because we regard it as a commodity belonging to us. When we see land as a community to which we belong, we may begin to use it with love and respect."

—Aldo Leopold, *A Sand County Almanac,* 1949
Author and U.S. wildlife biologist; cofounder of The Wilderness Society

"Let's get away from the idea that man is always and invariably an intruder in the wilderness, in nature. He has changed nature greatly, sometimes wisely, sometimes with the most appalling lack of wisdom. But man is as much a part of nature and the natural scene as a sequoia or a bear or an eagle."

—Herbert Evison
National Park Service Chief of Information, 1946–1958

"Conservation today means far more than just preserving our natural resources. It means their wise use and protection so that more and more people may enjoy and benefit from them. Only in so doing may our individual human resources be enriched."

—Laurance S. Rockefeller, 1955 speech at the National Conference on State Parks
American businessman, philanthropist, and conservationist

"It is a better world with some buffalo left in it."

 —Wallace Stegner, *This Is Dinosaur,* **1955**
 American writer, historian, and environmentalist

"Those who dwell, as scientists or laymen, among the beauties and mysteries of the earth are never alone or weary of life. Whatever the vexations or concerns of their personal lives, their thoughts can find paths that lead to inner contentment and to renewed excitement in living."

 —Rachel Carson, *The Sense of Wonder,* **1956**
 American author and environmentalist

"I went out in my alpine yard and there it was… hundreds of miles of pure snow-covered rocks and virgin lakes and high timber. Below, instead of the world, I saw a sea of marshmallow clouds."

 —Jack Kerouac, *Dharma Bums,* **1958**
 [about North Cascades National Park, Washington]
 American writer

"Men need to know the elemental challenges that sea and mountains present. They need to know what it is to be alive and to survive when great storms come. They need to unlock the secrets of streams, lakes, and canyons and to find how these treasures are veritable storehouses of inspiration. They must experience the sense of mastery of adversity. They must find a peak or a ridge that they can reach under their own power alone."

—William O. Douglas, *My Wilderness: The Pacific West,* 1960
Associate Justice of the U.S. Supreme Court, 1939–1975

"Yet, Man, for all his ego, is not the only creature. Other species have some rights too. Wilderness itself, the basis of all our life, does it have a right to live on?"

—Margaret (Mardy) Murie, *Two in the Far North,* 1962
The Wilderness Society council member

"It is the course of wisdom to set aside an ample portion of our natural resources as national parks and reserves, thus ensuring that future generations may know the majesty of the earth as we know it today."

—**John F. Kennedy, 1st World Conference on National Parks, 1962**
President of the United States

"I felt my lungs inflate with the onrush of scenery—air, mountains, trees, people. I thought, 'This is what it is to be happy.'"

—**Sylvia Plath, *The Bell Jar*, 1963**
American author

"Wilderness is an anchor to windward. Knowing it is there, we can also know that we are still a rich nation, tending our resources as we should —not a people in despair searching every last nook and cranny of our land for a board of lumber, a barrel of oil, a blade of grass, or a tank of water."

—**Clinton P. Anderson, *American Forests*, July 1963**
U.S. Senator from New Mexico

"The idea of preserving in a national grouping such spots of scenic beauty and historic memory originated here in this country…. In Europe, Asia, Africa, and Latin America, other countries have followed our pioneering example and set aside their most magnificent scenic areas as national treasures for the enjoyment of present and future generations."

 —Dwight D. Eisenhower, *Mandate for Change: 1953–1956,* 1963
 President of the United States

"The National Park Service today exemplifies one of the highest traditions of public service."

 —Stewart Udall, *The Quiet Crisis,* 1963
 U.S. Secretary of the Interior, 1961–1969

"Few of us can hope to leave a poem or a work of art to posterity; but working together or apart, we can yet save meadows, marshes, strips of seashore, and stream valleys as a green legacy for the centuries."

 —Stewart Udall, *The Quiet Crisis,* 1963
 U.S. Secretary of the Interior, 1961–1969

"If future generations are to remember us with gratitude rather than contempt, we must leave them something more than the miracles of technology. We must leave them a glimpse of the world as it was in the beginning, not just after we got through with it."

—Lyndon B. Johnson, speech at the signing of the Wilderness Act, 1964
President of the United States

"The national parklands have a major role in providing superlative opportunities for outdoor recreation, but they have other 'people serving' values. They can provide an experience in conservation education for the young people of the country; they can enrich our literary and artistic consciousness; they can help create social values; contribute to our civic consciousness; remind us of our debt to the land of our fathers."

—Stewart Udall, Committee on Interior and Insular Affairs hearings, 1964
U.S. Secretary of the Interior, 1961–1969

"Conservation, as we know it, is an American phenomenon, born of social reform, weaned by a dynamic national spirit, and shocked to its maturity by recognition that we the people have defiled a bountiful and beautiful land. Conservationists are trying to demonstrate that free people can act on their own behalf, voluntarily, willfully, and can dedicate their lands not to the profit of the few but to the good of the many. Today, conservation is clearly the concern of every American."

—Hubert H. Humphrey, speech at the *29th North American Wildlife and Natural Resources Conference,* 1964
Vice President of the United States

"The conservation clock is ticking too fast to be turned back."

—*The Race for Inner Space*, a 1964 publication of the U.S. Department of the Interior

"We seek now a NEW CONSERVATION—one of people as well as land and resources, one of the metropolitan areas as well as of open country."

> —**Hubert H. Humphrey, speech at the 30th *North American Wildlife and Natural Resources Conference*, 1965**
> Vice President of the United States

"Take away wilderness and you take away the opportunity to be American."

> —**Roderick F. Nash, *Wilderness and the American Mind*, 5th ed., 1967**
> American scholar of history and the environment

"Our concern is not to see that each and every part of the country has a National Park System installation. It is to see that all areas of national significance which are worthy of preservation of the society, their historical associations, their recreational opportunities, or their scientific interest are preserved."

> —**Wayne Aspinall, 1967 Congressional hearings**
> Chairman of the U.S. House Interior and Insular Affairs Committee

"Yesterday's conservation battles were for superlative scenery, for wilderness, for wildlife. Today's conservation battles are for beautiful cities, for clean water and air, for tasteful architecture, for the preservation of open space. To meet today's challenge, conservationists must project themselves into the mainstream of American life."

 —**George B. Hartzog Jr., 1967 speech**
 National Park Service Director, 1964–1972

"The love of wilderness is more than a hunger for what is always beyond reach; it is also an expression of loyalty to the earth, the earth which bore us and sustains us, the only home we shall ever know, the only paradise we ever need—if only we had the eyes to see."

 —**Edward Abbey, *Desert Solitaire: A Season in the Wilderness*, 1968**
 American author and nature writer

"In wilderness I sense the miracle of life, and behind it our scientific accomplishments fade to trivia."

 —**Charles Lindbergh, "The Wisdom of Wilderness," *Life*, 1967**
 American aviator, author, and explorer

"As we Americans celebrate our diversity, so we must affirm our unity if we are to remain the 'one nation' to which we pledge allegiance. Such great national symbols and meccas as the Liberty Bell, the battlefields on which our independence was won and our union preserved, the Lincoln Memorial, the Statue of Liberty, the Grand Canyon, Yellowstone, Yosemite, and numerous other treasures of our national park system belong to all of us, both legally and spiritually. These tangible evidences of our cultural and natural heritage help make us all Americans."

 —Edwin C. Bearss
 National Park Service Chief Historian, 1981–1994

"On the last day of the world
I would want to plant a tree."

 —W. S. Merwin, "Place," from *The Rain in the Trees*, 1988
 U.S. Poet Laureate

"I've been through legislation creating a dozen national parks, and there's always the same pattern. When you first propose a park, and you visit the area and present the case to the local people, they threaten to hang you. You go back in five years and they think it's the greatest thing that ever happened. You go back in twenty years and they'll probably name a mountain after you."

—**Morris K. Udall**, *Too Funny to Be President,* **1988**
U.S. Congressman from Arizona

"What a country chooses to save is what a country chooses to say about itself."

—**Mollie Beattie**
U.S. Fish and Wildlife Service Director, 1993–1996

"To be whole. To be complete. Wildness reminds us what it means to be humans, what we are connected to rather than what we are separate from."

—**Terry Tempest Williams**, *Red: Passion and Patience in the Desert,* **2008**
American author, conservationist, and activist

"Our National Parks belong to each of us,
and they are natural places to learn, exercise,
volunteer, spend time with family and friends,
and enjoy the magnificent beauty of our great
land."

 **—George W. Bush, announcement of National Park
 Week, April 2008**
 President of the United States

"Our National Parks have allowed generations
to discover history, nature, and wildlife in
irreplaceable ways."

 **—Barack Obama, Proclamation of National Park
 Week, April 2016**
 President of the United States

"THEY were THERE—each assigned to work
 the park
where they were born like a native species with
 inborn answers.
ready for my question marks: how big, how deep,
 how come,
how far, how old—those ranger badges held
 special powers…"

 **—Kathleen Heideman, from "Why I Want to Be a Ranger
 When I Grow Up," 2010**
 American poet and artist